MODERN AMERICAN PAINTING

TEXT BY

DORE ASHTON

A MENTOR-UNESCO ART BOOK

PUBLISHED BY
THE NEW AMERICAN LIBRARY, NEW YORK AND TORONTO
BY ARRANGEMENT WITH UNESCO

FIRST PRINTING, MAY, 1970

MENTOR TRADEMARK REG. U. S. PAT. OFF. AND FOREIGN COUNTRIES
REGISTERED TRADEMARK — MARCA REGISTRADA

MENTOR-UNESCO ART BOOKS ARE PUBLISHED IN THE UNITED STATES BY
THE NEW AMERICAN LIBRARY, INC.,
1301 AVENUE OF THE AMERICAS, NEW YORK, NEW YORK 10019,
IN CANADA BY THE NEW AMERICAN LIBRARY OF CANADA LIMITED,
295 KING STREET EAST, TORONTO 2, ONTARIO
PRINTED IN ITALY BY AMILCARE PIZZI S.P.A. MILANO

All through the first decades of the twentieth century, American artists lived in a rarefied situation, isolated by a society that scarcely noticed their existence. Sporadic eruptions of vanguard movements quickly disappeared in the face of general indifference.

The first American generation to make a cohesive impression on the world—born between 1900 and 1915 roughly, into a society in which an art community barely existed—inevitably nurtured themselves on remote contacts with the great modern movements in Europe. Through rare exhibitions of the works of Picasso, Matisse, Braque and, later, Miró and the Surrealists; through the illustrated pages of advanced European magazines; and through the few Europeans who settled in the United States during the 1930s, Americans formed their image of what it meant to be a painter in the modern tradition.

Those who early learned to resist local traditions, such as journalistic illustration or 'American scene' painting, looked in many directions for a suitable starting point. Some were excited by the austere idealism of Mondrian, whose works they might have seen in an important exhibition, *Cubism and Abstract Art,* at the Museum of Modern Art in 1936. Others were inspired by the aesthetic liberties represented in an exhibition of the same year, *Fantastic Art, Dada, Surrealism.* Still others were fired by Léger, who spent some time in New York during the 1930s, or by the works of Kandinsky, visible in the Guggenheim collection at the Museum of Non-Objective Art which opened to the public in 1939.

These young rebels could not mature calmly in their

chosen idiom. Circumstances of a highly disruptive nature intervened. While they were yet very young painters, the United States entered a period of severe economic crisis which was to affect every aspect of the society including the arts. The Depression was without question a traumatic experience in the lives of all artists. It was not simply a matter of economic hardship. The Depression brought with it a tremendous upheaval in received political and social ideas. The sight of starving children and breadlines and the desperate wanderings of unemployed farmers shocked the intelligentsia deeply, and a vivid public outcry ensued bringing with it many probing social, political, and aesthetic discussions that could not fail to rouse the painters.

The emergency called forth a special government agency, the Works Project Administration, designed to offer economic assistance to artists. In the easel and mural projects of the WPA, nearly all the future Americans of international reputation, forming a community for the first time in American history, were to meet and discuss the pressing aesthetic problems of the moment. The most imaginative among them were anxious to avoid the trite solutions offered by American social realist painters who catered to the traditional public hunger for anecdotal painting. And yet, they were troubled by a need to respond articulately to the great crisis.

In their wish to reconcile the abstract modern tradition with the expression of themselves as conscientious men in society, many painters looked to the Mexican muralists for inspiration. Siqueiros, Orozco and Rivera had all visited the United States and painted murals during the 1930s. Often this was done in public with the assistance of young American artists. Siqueiros had even founded an experimental studio in New York in 1936 where Jackson Pollock and others probably first began to explore new materials such as Duco and sprayed paint.

Besides the Mexicans, there was Picasso, whose *Guernica*, with its fusion of tragic, readable symbolism and abstract painting devices, made a deep impression on many painters. Picasso's expressionist distortions satisfied

the troubled psyches of several significant American painters. They responded to his anger with familiarity, and grew from it, as they also grew from their exposure to the thoughts and paintings of the Surrealists.

Some of the men of the generation born between 1900 and 1915 were early defenders of abstract painting and, in 1936, formed an artists' organization, 'The American Abstract Artists'. "We place a liberal interpretation on the word 'abstract' " they proclaimed in their 1937 prospectus—an interpretation which was to allow for the original variations on European abstract idioms that earned several painters their reputations as pioneers.

At the outbreak of the Second World War, American artists had succeeded in forming a coherent community which had finally attracted the attention of the society at large. There were now a few museums exhibiting their paintings, a few vigorous galleries defending them, and a few commentators publishing sympathetic criticism. Their position was enhanced by the arrival of many European masters, among them Max Ernst, André Masson, Fernand Léger, André Breton, Yves Tanguy and Piet Mondrian, who had all long since impressed themselves upon the American art public and who quickened the artistic life which was centered mainly in New York City.

An incipient movement among American painters—a movement not yet focused, and certainly not yet articulated in written theory—was given further impetus by the electrifying presence of European *émigrés*. An already formed painter such as Arshile Gorky was nonetheless strongly affected by the interest of the august surrealist poet André Breton. Younger men, among them Jackson Pollock, William Baziotes and Robert Motherwell, found important encouragement when Peggy Guggenheim opened her Art of This Century gallery in 1942—a gallery which became a café-like centre where artists and *cognoscenti* could meet and argue the important aesthetic issues that were emerging.

These issues—the issues that were the inspiring forces in the abstract expressionist movement—were extremely complex, coloured as they were with psychological, philo-

sophical, moral and political considerations. The reason it is difficult to define with any precision the nature of the abstract expressionist movement is precisely because strictly plastic problems were not solely at issue. Unlike Cubism, which had clear formal preoccupations and found plastic means to enunciate them, Abstract Expressionism had no formal prescriptions. Rather, it expressed an attitude toward the nature of the painter's situation, and the nature of the painting act. It was, in short, a philosophically inclined, spontaneous movement toward openness. Its first principle was the rejection of dogma of any kind. Rather than trying to define specific plastic means, the abstract expressionist temperament sought to express experience by any means that would finally be meaningful.

By 'meaningful' the painters of this generation meant that they were determined to avoid decorative painting, or any given style that had become merely the skillful manipulation of painterly means, no matter how *avant-garde* those means appeared. They wished their paintings, even their fully abstract paintings, to have what they called either a 'subject' or 'content'. Finally, what such an attitude had to signify was the will of the artist to make his intention known through the work; to make his philosophical concerns visible.

Because of the openness of the abstract expressionist aesthetic, individual responses were extremely varied. For a time, during the first years of the war, many artists sought to infuse their abstractions with 'content' by resorting to fundamental myths. Some actually utilized the myths of Antiquity. Others invented their own myths, or used the mythological voice.

This was true of Arshile Gorky (Plates 4 and 5) especially. He had come to America as a boy from Turkish Armenia. Although all his artistic training was in the United States, when he sought to open his painting and move away from his primary sources, notably Picasso and Miró, one of the first things Gorky did was to invent a personal mythology, having to do with his childhood. Largely by means of this distancing from the well-known modern

idioms on which he had trained himself, Gorky was able to develop his singular style.

The style, characterized by André Breton in a well-known essay of 1945, as 'hybrid', in which "for the first time nature is treated as a cryptogram", allowed Gorky to combine his interest in 'content' with his feeling for occult relationships of biomorphic forms. Gorky, in his mature phase, painted with thin, luminous colours counterpointed by singularly fine painted lines. He allowed his colours to run at times, and he aimed always to preserve the luminosity of his basic plane. Strange spaces, totally removed from traditional perspective either of the Renaissance or cubist epochs, encompassed the pulsating forms that floated gently in Gorky's last works. The events on the canvas reflected the tremendous synthesis of ideas and forms Gorky had so carefully prepared for twenty years. Both his expressionism and his impulse toward abstraction were held in a delicate balance that seemed to many younger painters totally original.

His close friend, Willem de Kooning (Plates 6 and 7), was also an immigrant, arriving in the United States in 1926 well armed with a traditional training and a background in modern European movements. De Kooning, however, always moved a little apart from the others. After working in a 'hybrid' style, compounded of expressionist and cubist elements, during the late 1930s and early 1940s, de Kooning, shortly before his first one-man exhibition in 1948, began to paint abstractions. He used free-flowing enamels, and allowed his compositions to thrust their feverish way seemingly beyond the confines of the canvas. These abstractions, in which plane upon plane, and disconnected form upon form, thrust vigorously on the surfaces, led de Kooning further into expressionism. His much-emulated brushwork—the dense, sweeping stroke of a wide brush, with its hooking deviations, and its characteristic twists—was used to enunciate an idea about the human figure, a figure that was intimately involved with, invaded by, and dependent on its environment. Of all the painters who had shared the perturbation over figure painting which troubled the

1930s, de Kooning was the only one who continued to seek its possibilities. De Kooning's leap beyond the well-ordered spaces of Cubism in his abstractions, and his development of modern expressionist figure painting, were to play an incalculable rôle in later American painting. Moreover, it was largely through de Kooning's nervous temperament, which found excitement in the act of painting through which his 'content' revealed itself, that the notion of 'action painting' as Abstract Expressionism is alternately called, gained credence.

De Kooning shared with Jackson Pollock (Plates 2 and 3) the stress on the importance of the act itself, with all the physical and psychical participation that implies. Pollock's early admiration for Tintoretto, Greco and, later, the Mexicans and Picasso, indicated the expressionist nature of his temperament.

In 1943, when he had his first one-man exhibition at Peggy Guggenheim's gallery, Pollock was painting thickly encrusted, expressionist works in which his penchant for recasting ancient or primitive myths was apparent. Through distancing the content, Pollock was able to move freely into unexpected patterns in which perspectives were inconsistent, and the surface teemed with painterly detail.

Toward 1947 Pollock sought an intimate spatial solution by placing his canvas on the floor, and working over its surface, often dripping viscous paint from sticks in widening arabesques. These linear arabesques, superimposed, form a rhythmic, perpetually moving image in which depth is illusory and the extension of the rhythms infinite. These very large canvases (Pollock had been very much interested in murals) were emphatic statements of his attitude toward the nature of painting. He emitted his painting as a spider emits his silk, and he felt, as he said, "nearer, more a part of the painting" when he worked on the floor and could "walk around it, work from the four sides and literally be *in* the painting".

By standing over his canvas, Pollock radically changed the nature of his spatial image. It was no longer based on a man standing before an easel, his eye level with his canvas, his hand raised with a brush. Everything about

the painting, then, was different from traditional abstract painting, and the most important difference was in the types of continuous space experiences he was describing.

Less emphasis was placed on the physical changes in the nature of painting by other artists of his generation. Mark Rothko (Plates 10 and 11), for instance, was more concerned with spiritual and ethical problems through which his means were ultimately strikingly altered. In the early 1940s, Rothko, Adolph Gottlieb (Plate 12) and many other artists had, like Pollock, been deeply interested in surrealist theories of psychic automatism. Impressed by the importance of subconscious materials in the creative process, they had searched further, amid the origin myths, for a kind of moral force they felt lacking in modern painting.

Rothko, who conceived of his paintings as symbolic dramas at the time, worked with thin, pale, flowing forms that were intended to recuperate the direct spiritual meanings of primitive cultures. He voiced his belief in the importance of subject-matter on several occasions, and insisted, as did Adolph Gottlieb, Barnett Newman and William Baziotes, that there could be no valid painting without a subject. Or, as he said, "about nothing".

When, toward the late 1940s, the wispy symbols that had floated so mysteriously in his paintings were dissolved into a simple scheme of rectangles, Rothko still did not relinquish his vision of painting as a philosophic enterprise. His deeply resonant colours, applied in thin veils which trembled gently on the surfaces, seemed to call forth the contemplative situation with which he had always been involved. Rothko's late paintings, more than ever concealing an interior light source, reveal themselves slowly, in stately rhythms, and induce a mood of contemplation that is rarely equalled in modern painting.

The subtle expansion of Rothko's spaces was quite different from the powerful spread of lateral space conceived by his colleague Clyfford Still (Plate 9). Like the other Abstract Expressionists, Still had had a moment of mythmaking which was supplanted by abstract paintings in which the brooding, violent atmosphere of ancient

myth remained. Great spreading fields of dense paint were abruptly rent by lightning-like eruptions. These breaks in an opaque surface served to emphasize Still's refusal to use any traditional painterly means. His insistence on the impermeability of the final visible plane, and its extension on all sides but not inward, was in accord with the abstract expressionist rejection of cubist representation of space, and its interest in powerful, embracing images.

Such conscious rejection of the most significant modern tradition was implicit in the work of Robert Motherwell (Plate 1), who, more than the others, had schooled himself in Cubism, and was especially interested in collage. Gradually he worked out from cubist, planar constructions into the wide, laterally extending compositional mode favoured by others. Motherwell's concern with 'subject' was profound. He had a vision of a fusion of ethical concerns with aesthetic form. His specific themes, such as his elegies to the fallen Spanish Republic, were the psychological spurs for the development of abstract paintings that were analogous to experiential situations for him. The great freedom, both in terms of motif and technique, that Motherwell experienced during the height of the abstract expressionist period has never ceased to express itself in his œuvre.

Freedom from the past was certainly one of the rallying principles of the Abstract Expressionists. But even older artists such as Mark Tobey (Plate 13), who already in the 1930s had conceived of his new spaces in his 'white writing' paintings, and Hans Hofmann (Plate 17), who had experimented with many techniques and idioms in a highly liberated spirit, were singularly equipped to cast off the rhetoric inherited from early twentieth-century masters.

What can be called the abstract expressionist attitude— a spirit of freedom from binding conventions and an emphasis on the psychological value of process itself in painting—affected artists at different moments in their personal evolution. Bradley Walker Tomlin, Jack Tworkov, James Brooks, John Ferren, Hedda Sterne and many

others chose various moments to enter the spirit of Abstract Expressionism.

One of the singular painters in the movement, Philip Guston (Plate 14), moved out of a sophisticated romantic realist style into the free fields of abstraction only in the late 1940s. Guston's initial break was radical. He brought his symbols close to the picture plane, banished prospects in depth, and soon left discrete symbols behind. He began to shape floating, ambiguous images in light hues that depended on the grouping or disassociation of isolated paint strokes. All reference to previous modes of spatial representation quickly disappeared from his paintings.

Toward the mid-1950s, Guston evoked singularly suggestive imagery in the abstract forms that emerged as his brush moved over the surface, now tracing delicate linear interplays, now heavily loading the surface with coalesced strokes in relief. Spaces shifted. Forms hung uncannily from a hidden source just behind the picture plane. Indeterminate movements in colour mutations and the profiles of the painted forms kept focus-points forever shifting. It is as if Guston were seeking to represent the very movements of his imagination, rather than the symbols it was shaping. This attempt to picture forth the very process of imaginative thinking found strange, compelling embodiments.

Franz Kline (Plate 8) was also slow to leave behind representation. Only in 1950 did he emerge with the stark black-and-white paintings for which he is celebrated. Kline's interest in the sweep of a broad path of black, as it charges through the atmosphere, led him to a symbolization of space unlike anyone else's. The illusory emptiness of his whites was quickly transformed before the spectator's eyes as tangible, charged media through which the black strokes propelled themselves at various speeds. Emptiness, or the virtues of silent intervals, were very much a part of abstract expressionist thought. Other painters, notably Sam Francis (Plate 21), were also specifically interested in these silent zones.

The virtues of large areas of colour, unmarked by the visible brush stroke, were expounded by Barnett Newman

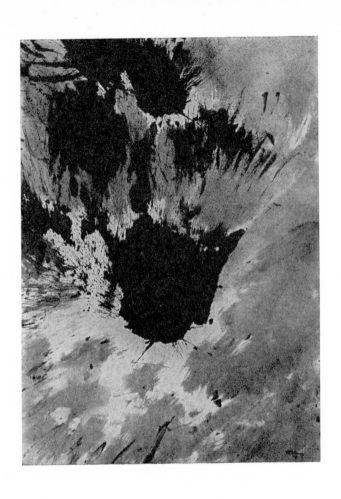

*Mark Tobey. Space Ritual No. 3. 1957. Sumi Ink. 29 x 21 in.
Collection Robert and Jane Meyerhoff. (Photo: Oliver Baker)*

(Plate 15) who, around 1950, began to work with broad, unmodulated fields of colour accented sparingly with vertical bars. Newman had shared with Rothko and Gottlieb in the early 1940s a deep interest in the motivation of the primitive artist. He resolutely opposed all Renaissance and modern conventions in the belief that he could, as he wrote in 1947, embody in painting the primitive painter's "abstract thought-complex, a carrier of awesome feelings he felt before the terror of the unknowable".

Later, Newman asserted that his broad, simple colour planes were based on a vision of 'whole' spaces that had not been painted before. He continued to insist that his work had an ethical ground, and that one of its implications is "its assertion of freedom, its denial of dogmatic principles, its repudiation of all dogmatic life". These broad and simple paintings, in which colour extended out of range of the single glance and was lightly inflected by a stripe or two, were to provide many younger painters with a starting point for their own rebellion from convention.

If the breadth of the abstract expressionist attitude could encompass artists as divergent as Pollock and Newman, it brought forth in others a fruitful resistance. One of the most vigorous resisters playing an important rôle as *provocateur* in many public conversations among the Abstract Expressionists was Ad Reinhardt (Plate 18). His apostasy was expressed both in the satirical collage-cartoons he published, and in his ripostes to his abstract expressionist colleagues. Where they proposed an open aesthetic, in which the singular gesture of the painter was valued, he proposed a closed, static vision of modern painting, free of the particular events celebrated by the Expressionists, and calmly universal.

Reinhardt was a member of the American Abstract Artists, and had been nurtured in the clear vision of the non-objective successors of Mondrian. His brief interest in 'all-over' space, and the softly spreading symbols favoured by some Abstract Expressionists culminated in a series of renunciations during the early 1950s—renuncia-

tions which brought him ultimately to an austere schema (five foot square canvas with nine quadrilateral, equal, interior divisions) which he refused to vary. In these schemas, Reinhardt painted infinitely subtle gradations from black to deep grey, that could be grasped only after intense scanning. The paintings made themselves known only through time, and through their vague and almost imperceptible interruptions of silences. In this, Reinhardt kept up a dissenting voice, since his extremely reticent paintings were diametrically opposed to the prevalent emotionalism of Expressionists. In a sense, Reinhardt achieved through the absence of colour what the older Josef Albers (Plate 19) achieved in his *Homage to the Square* series, in which colour was to act as independent of specific form as possible. The square, as both Reinhardt and Albers believed, was the most neutral carrier on which their painting could perform.

As a pervasive movement, Abstract Expressionism was no longer dominant at the end of the 1950s. Yet, its permissive context gave rise to many individual statements that had received their initial impetus during the height of the movement. The mature artists that formed its base continued, in many cases, to explore, and in some instances—Motherwell, for example—expanded its vocabulary considerably. It became clear that it was not the physical act of painting or the expressionist brushwork that defined Abstract Expressionism, but the intention of showing forth, in abstract images, a vision of the correspondence between vital forms as they move in created spaces and the way the painter experiences the events in his life.

Among those who appeared later was Morris Louis (Plate 30)—of the same generation as Pollock—who developed his unique stained paintings only in the late 1950s. He took his method of work from the younger artist, Helen Frankenthaler (Plate 22) who, in her lyrical, thinly stained paintings had proposed a sensuous way of apprehending form and colour based on the perspective established by Pollock. Helen Frankenthaler's freely expressive manner, which has enabled her to expand and

simplify her style constantly without losing its volatile lyrical quality, inspired Louis. He in turn produced paintings in thin layers of colour, purely diaphanous, spreading in leisurely movements over his canvas. The permissions inherent in Abstract Expressionism led Louis to further extensions. He began to simplify, seeking to allow irregular bands of high-keyed colour to take the burden of expression. In his later work, the void, defined by clusters of coloured lines moving out of the sides of long horizontal canvases, became a compelling subject which he articulated in a series of paintings known as 'unfurls'. Louis' treatment of the canvas as a primal source of light, and his informal simplifications that made colour the chief agent, impressed scores of younger artists who wished to work with colour, but rejected the compositional rigour favoured by the more classical geometric non-objective artists.

Several artists, while still functioning in the abstract expressionist aesthetic, were clarifying and simplifying, leaving behind the complex ambiguities that once characterized their work. Adja Yunkers (Plate 23), of the original generation, began to work with few colours, flat areas, delimiting the swelling forms that had always dominated his work with unequivocal edges. Jack Youngerman (Plate 29), of the next generation, broadened and flattened his organic imagery, stressing the surface of the picture plane. Al Held (Plate 27), also a member of the next generation, retained the thick impastoes of his apprentice years, but used them to articulate vast surfaces, punctuated with neutral, clear forms ranging from triangles and circles to erratic curves. And Deborah Remington turned to clean, brittle surfaces and sharp lighting while retaining ambiguity in her imagery. These are only a few of the many artists who were to find within the abstract expressionist attitude many possibilities of amplification.

Others of the next generation turned away from the principle of pure abstraction in many directions. Times had changed. There was a large new public, made prosperous in the post-war boom, and eager for quickly

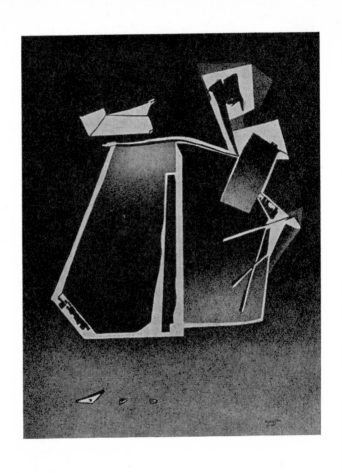

Deborah Remington. "Adelphi Series". Drawing in pencil. 16 x 12 in. Galerie Darthea Speyer, Paris.

shifting modes and new sensations. The time welcomed all manner of iconoclastic utterance, preferably swiftly registered and not fraught with pretentious philosophical overtones. Younger artists themselves were weary of the philosophic, lofty rhetoric of the Abstract Expressionists. One of the strongest expressions of disaffection emerged in the work of Robert Rauschenberg (Plate 24) who set out to disabuse his public of its illusions. First, in a gesture recalling his roots in Dada, Rauschenberg offered a suite of untouched stretched canvases as works of art. Next, he began to load his canvases with bits of debris—newspaper shreds, photographs, tattered rags. Still later, he mocked expressionist brushwork, using it to set off imposed, ready-made images. His notion of the 'combine' in which the detritus of daily urban life was joined with the painted image was clearly antithetic to abstract expressionist theory. Rauschenberg's lively interpolation of materials that had no intrinsic value began a large public discussion concerning the nature of modern art—whether it could indeed be made to reflect the nature of modern life more directly. Out of this ferment bubbled up an obstreperous movement known as Pop Art. The majority of its practitioners deliberately attacked the notion of abstraction and 'high' art by making use of popular imagery. The epitome of the movement is represented in the works of Roy Lichtenstein (Plate 31) who successfully incorporated the comic strip in his carefully designed paintings, and gained an international reputation for it. James Rosenquist (Plate 32), adopting the manner of the great outdoor sign painters, also leaned heavily on the imagery derived from popular magazines, making commentaries on certain American obsessions, ranging from food and cars to sex.

Not long after Rauschenberg had impressed himself upon the world as the protagonist of a new point of view, Jasper Johns (Plate 25) stepped forward with his elegantly rendered images of the American flag. In deliberately choosing a motif which would strike the knowing viewer as the height of banality, Johns injected his note of dissent. Soon he added numbers, letters and targets

to his painting vocabulary, rendered with painterly finesse. The content of painting, seen by the Abstract Expressionists as a most serious affair, was made to seem in Johns' work a secondary concern at best. Like Rauschenberg, he did not hesitate to use three-dimensional objects, combining them with his paintings, suggesting that a painting was not an ideal closed universe, but only one thing among many.

The notion that a painting was, after all, only one among many objects of interest in the world, and that there was something sentimental about the way the Abstract Expressionists invested painting with such high ambitions, took firm hold at the beginning of the 1960s. The use of commonplace imagery in the service of painting found many advocates, among them Allan d'Arcangelo (Plate 26) whose images of the vast and lonely highways traversing the American landscape announced his original attitude toward the content of painting. Taking his cue partly from the pop artists, he bent his representational motifs to the service of plastic ideals that represented the almost universal hunger at that point for factual clarity and unequivocal statement.

Much more radical in its intention was the initial gesture of Frank Stella. Among the many aspects of the abstract expressionist styles that he wished to avoid was the habit of drawing with a brush. Sweeping previous canons before him in a fierce *tabula rasa* action, Stella began to paint shockingly simple canvases, sometimes consisting only of a series of blackish verticals placed with equal intervals on an unprimed canvas. In his early stages, Stella worked only with charcoal blacks and the thin light areas of canvas between stripes. If he made a pattern it was symmetrical, sometimes based on the central cross from which sections radiated to the edge. By eliminating colour and particular form, Stella attained an austere painterly statement of his belief that the fact of a painting was self-sufficient. Like others of his generation, he looked with great suspicion upon the lyrical associative techniques of the Abstract Expressionists. He wished to effect

a catharsis of painting rhetoric; a general housecleaning which would leave only the visible fact itself to be reckoned with.

Later, Stella intensified his statement of the object-status of painting by altering the shape of his stretcher and carrying out the interior motifs to emphasize the importance of the object's shape. He and many other young painters during the early 1960s were, for a time, deeply engaged in exploring the nature of the image bearer. They asked why a painting had to be rectilinear, and answered bluntly that they could find no reason, since, as an object, it could take any form. Naturally, in order to stress objective quality, these painters had to accept the old modern notion of the primacy of the picture plane. Any illusionistic depth would destroy the sense of independent objecthood.

Stella, however, could not long be held to a narrowed vision and, after having condensed his imagery so severely at the very beginning, moved in the reverse direction, complicating it with the manipulation of colour, texture and form. His most recent works are tremendously complex and witty plays on the nature of roughly geometric forms, and the degree of interplay possible within given geometric schemes. He feels free to allow planar overlap and other illusionistic devices to enliven his canvases. As firm and geometric as his contours are, and as flatly applied his colours, Stella's large new works share more stylistically with the Abstract Expressionists than with the more dogmatic minimalist painters (Plate 28).

If he shares the affection for large format and free colour play with the older generation, Stella is still ideologically a man of his own generation. It is a generation that prefers the lean descriptive rhetoric advocated by Wittgenstein to the lyrical oneirism of Jaspers or Jung; a generation that no longer believes in metaphorical or hierarchical values, and prefers to deal only with visible, tangible and describable reality. The painting, in this context, is not magical or even unique. Stella and many of his contemporaries underline the fact that their paintings are produced in series; that the

'content' is only what is there on the surface; and that there is no reason to believe that the first or last of the series is better or more significant than any other segment in the series. To this degree it is a polemical generation, consciously determined to overthrow an uncongenial aesthetic inherited from their immediate predecessors.

Many of these young painters have chosen to isolate certain given painting means and deal with them exclusively. Line or colour or shape become, in themselves, areas for exploration. An important painter who tends to stress a single means at a time to the exclusion of all others in various phases of his work is Ellsworth Kelly (Plate 20). When he draws, as he does regularly, Kelly works from nature; but he uses pure line, determining the spaces between leaf forms, the extensions and roundness of stems, all by means of precise contour line. Similarly, when he paints, certain of his abstractions, in which large, curving areas seem to fill up the frontal plane, the description of the curve is precise. It is the source and meaning of his painting which is at times rendered in only two colours. In other series, Kelly eschews particular forms altogether, and works with rectangles of adjacent colour. The colour is chosen for its resonance in relation to its neighbours, but it becomes clear to the viewer that each colour area is also an emphatic entity in itself. By limiting himself to the effects he can achieve by the use of colour alone, Kelly articulates a particular attitude toward the painting: it is a visible object with special qualities of light, and does not presume to be more or less.

In practice, a purist attitude such as this is never fully conveyed in painting. Each time an area is divided and each time two colours are juxtaposed a host of visual ambiguities announce themselves in spite of the artist's pure intentions. Kelly has an instinctive tact which never permits him to oversimplify, or to flatten his imagery completely. No matter how reductive the non-objective painters wish to be, they fortunately keep finding new challenges right on the surface of their canvases.

If the present mood is one of renunciation and purifica-

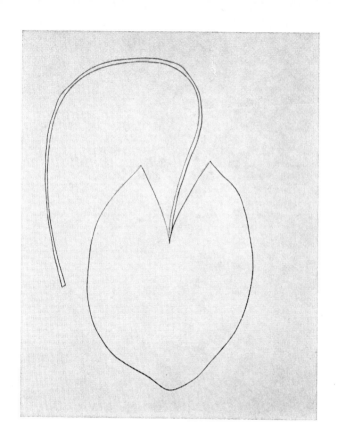

Ellsworth Kelly. Water Lily (29.68). 1968. Drawing in pencil.
29 x 24 in. Collection of the Artist. (Photo: Geoffrey Clements)

tion—an implicit challenge to the very existence of painting—it does not exclude the clamorous simultaneous existence of many modes of painting. Since that first lonely *avant-garde* which languished for want of the interest of its society in the first two decades of the century, much has changed in the United States. The increasing menace of technology when applied heedlessly to problems that can only be met with thoughtful, humanistic solutions, has heightened interest in works of the imagination. A society that now feels vaguely threatened by the very forces of progress that once absorbed all its energies turns more and more toward the arts for both solace and enlightenment. The obvious hunger for painting, which is inevitably associated with culture, has sustained a large population of artists throughout the country practising in styles as different as figurative, purist, minimalist, expressionist, symbolist and pop. Finally, recent social turmoil has called forth an attempt to revive the genre of protest painting, as an artistic equivalent to the revolutionary guerrilla movements in the world.

ILLUSTRATIONS

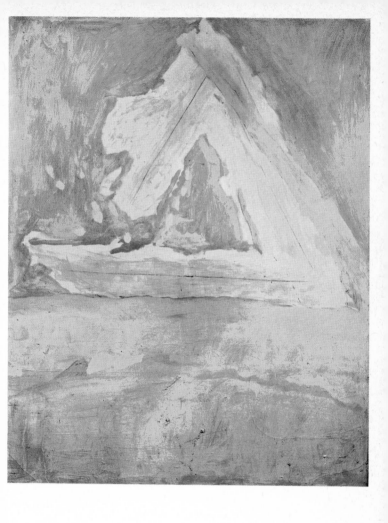

1

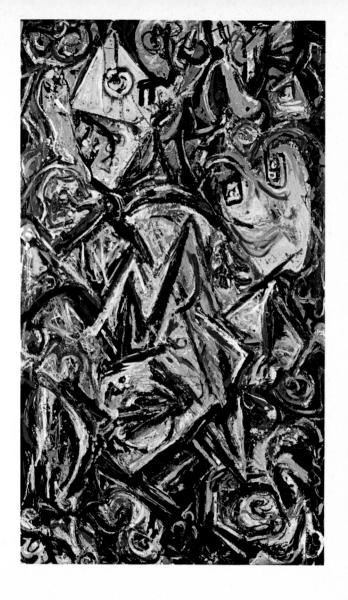

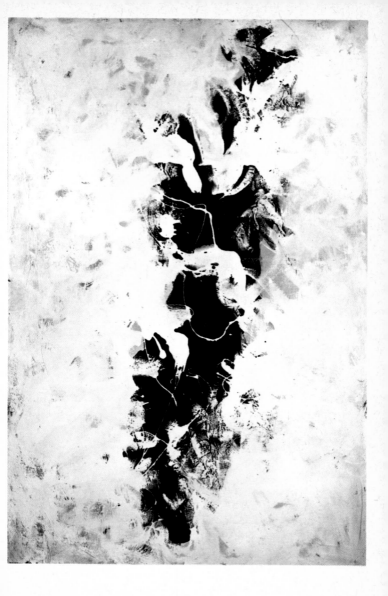

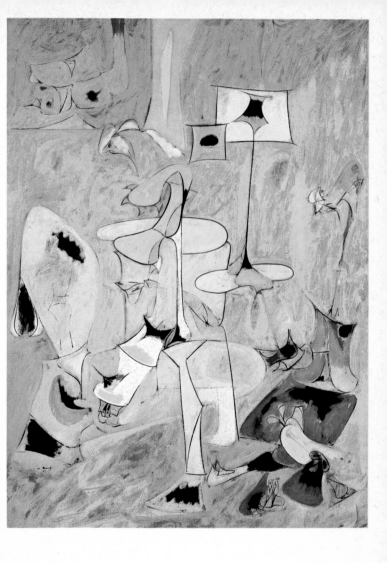

4

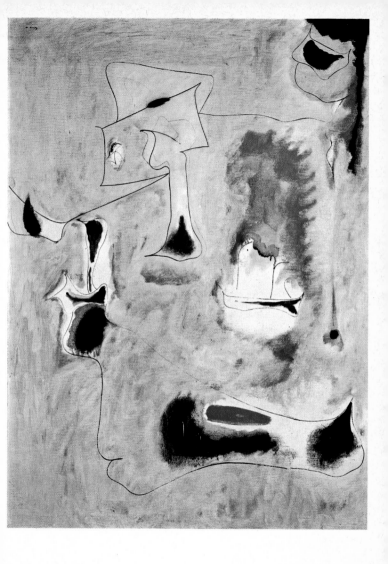

5

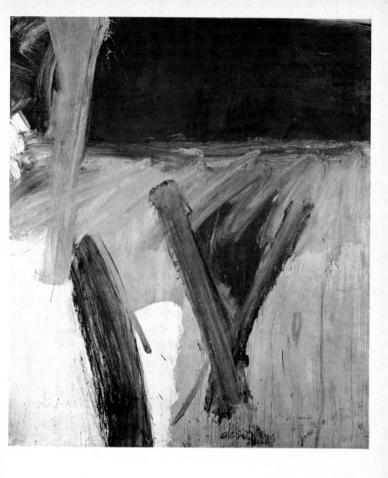

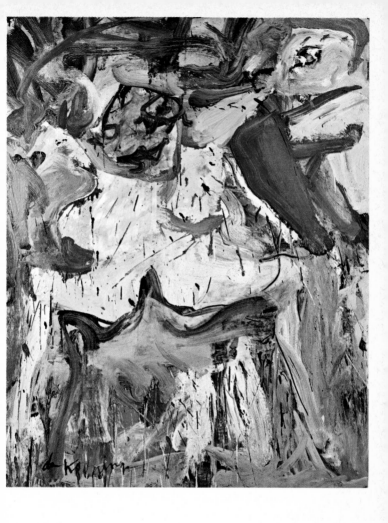

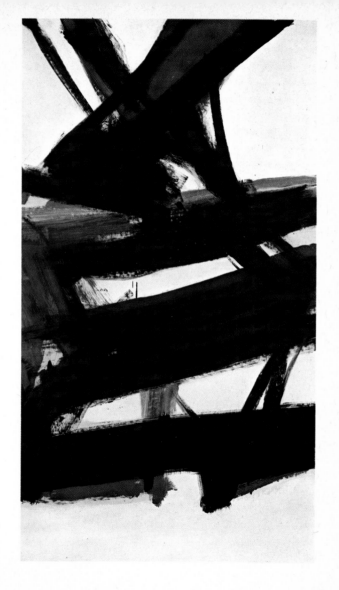

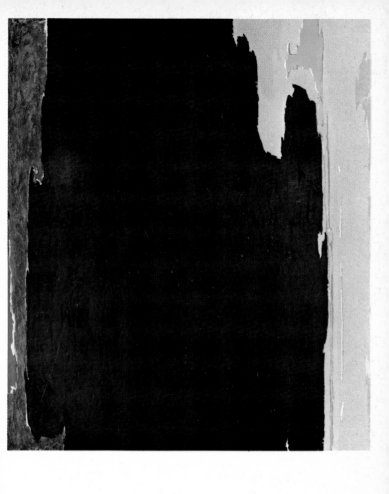

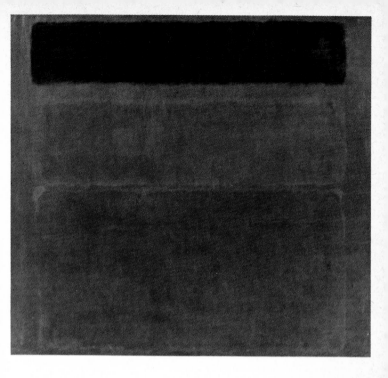

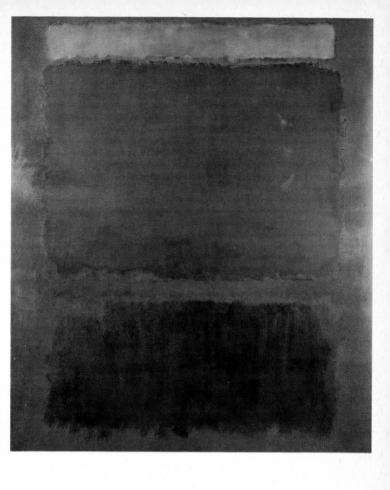

11

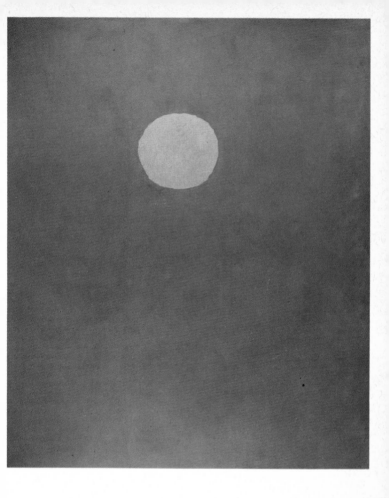

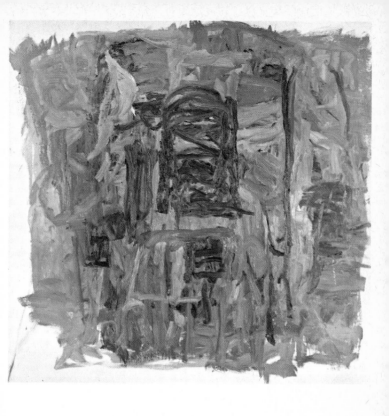

14

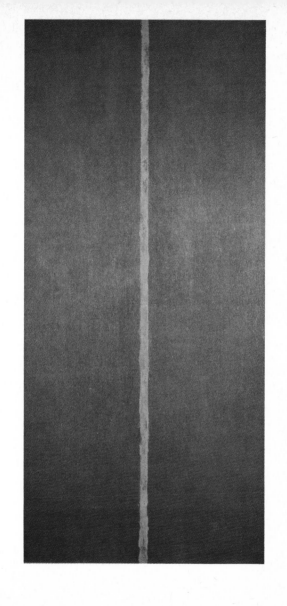

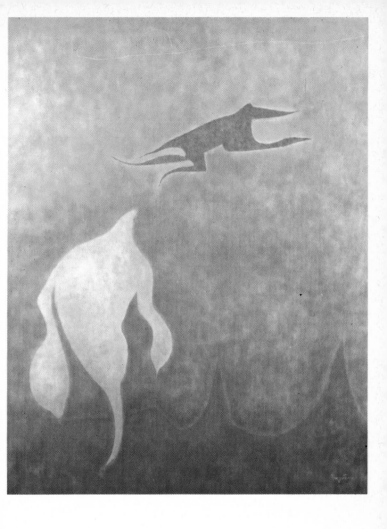

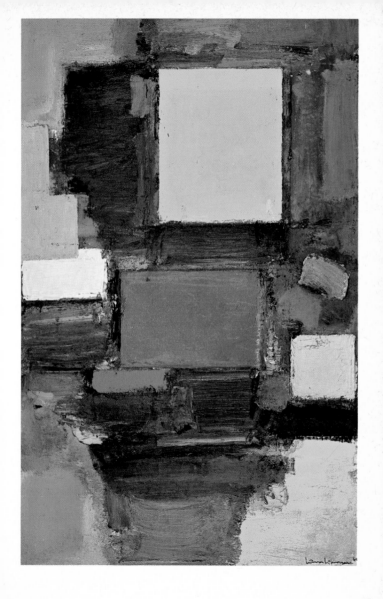

17

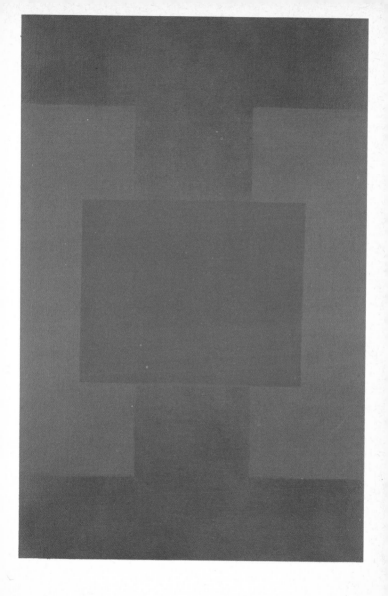

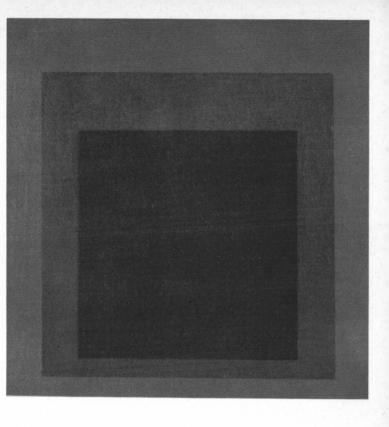

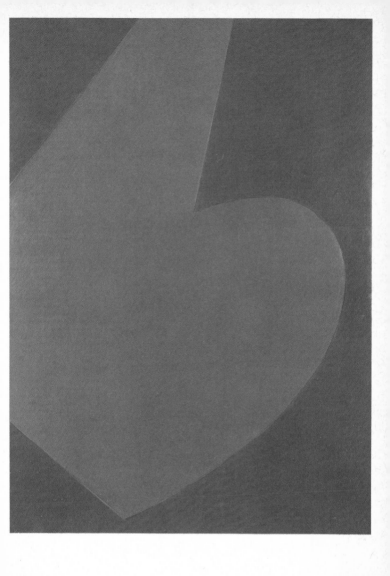

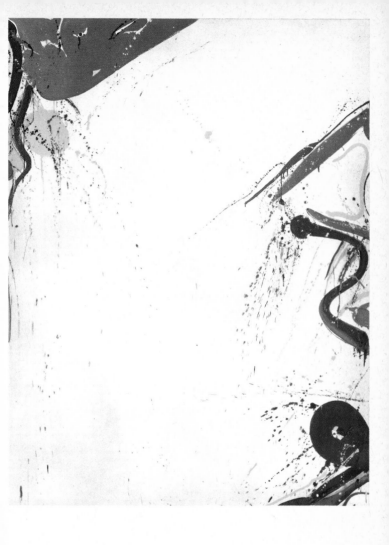

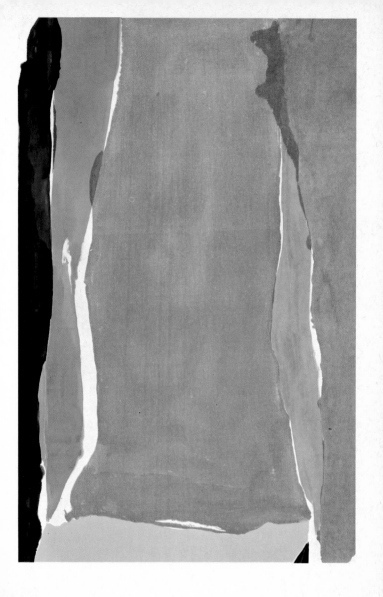

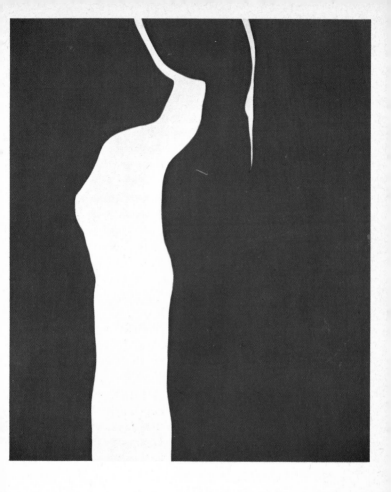

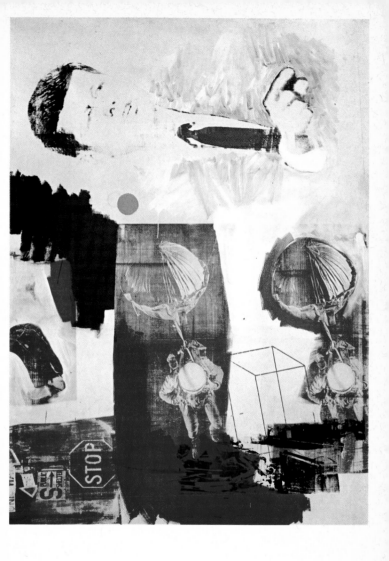

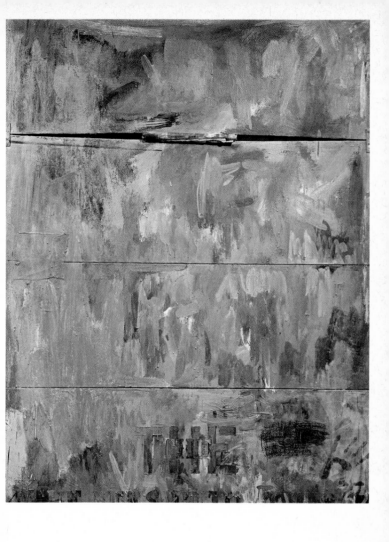

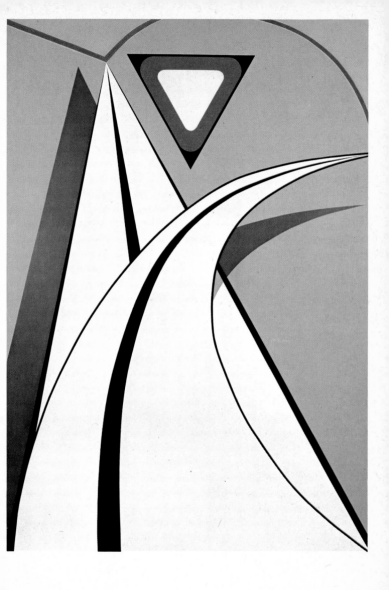

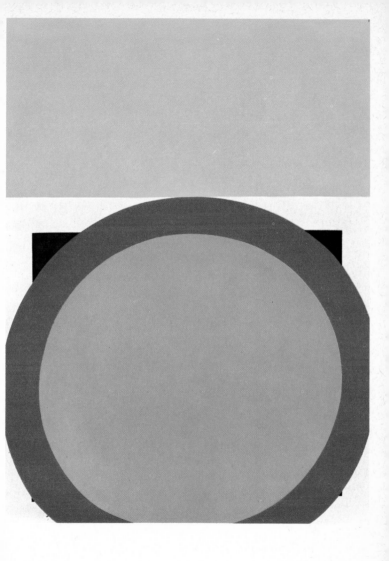

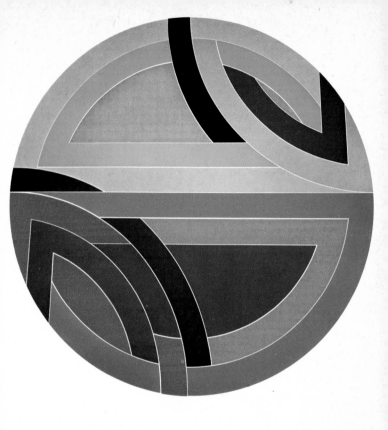

28

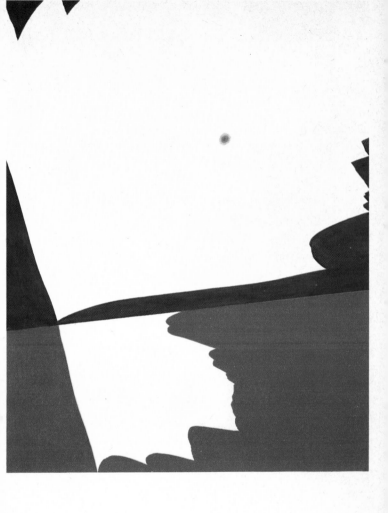

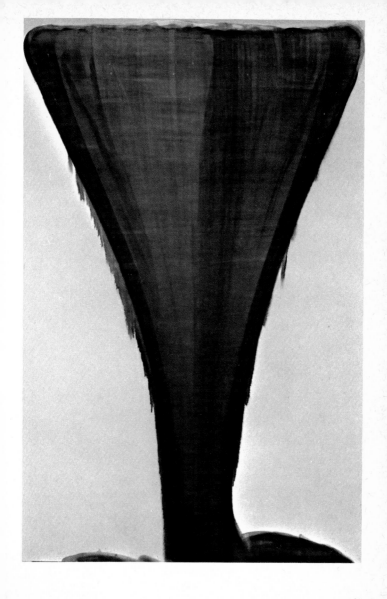

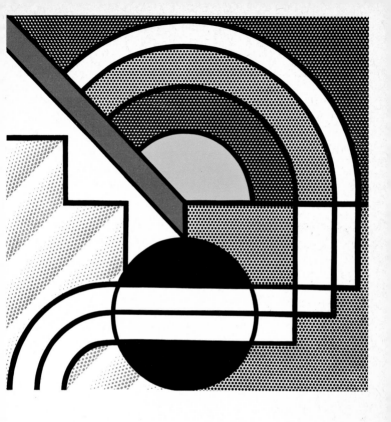

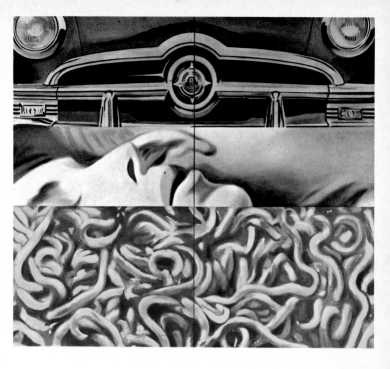

CONTENTS

CONTEN

BIBLIOGRAPHY

General Works

"American Abstract Artists", *The World of Abstract Art*, New York, Wittenborn & Co., 1957.

Art Since 1945, New York, Harry N. Abrams, Inc., 1958.

Ashton, Dore, *The Unknown Shore: A View of Contemporary Art*, Boston, Little, Brown & Co., 1962.

Baur, John I. H., *Revolution and Tradition in Modern American Art*, Cambridge, Harvard University Press, 1966.

Greenberg, Clement, *Art and Culture*, Boston, The Beacon Press, Inc., 1961.

Guggenheim, Peggy, *Confessions of an Art Addict*, New York, The Macmillan Co., 1960.

Hess, Thomas B., *Abstract Painting: Background and American Phase*, New York, The Viking Press, 1951.

Hunter, S., *Modern American Painting and Sculpture*, New York, Dell Publishing Company, Inc., 1959.

Modern Artists in America, New York, Wittenborn, Schultz, Inc., 1951.

Possibilities, An Occasional Review, New York, Wittenborn, Schultz, Inc., Winter 1947-48.

Rose, Barbara, *American Art Since 1900, A Critical History*, New York, Praeger Inc., 1967.

Rosenberg, Harold, *The Tradition of the New*, New York, Horizon Press Publishers, Inc., 1959.

Rosenberg, Harold, *The Anxious Object*, New York, Horizon Press Publishers, Inc., 1964.

Printed in Italy

MODERN

AMERICAN PAINTING